The Wild West

The Wild West

Photographs by David Levinthal

Smithsonian Institution Press, Washington and London
Published in association with Constance Sullivan Editions

This series was developed and produced for Smithsonian Institution Press by
Constance Sullivan Editions

Series editor:
Constance Sullivan

Smithsonian editor:
Amy Pastan

Designed by Katy Homans

First edition

Printed by Meridian Printing, East Greenwich, RI, USA

cover: *Rearing White Horse*, 1988

The photographer wishes to thank Barbara Hitchcock and the Polaroid Corporation for their
generous support; especially John Reuter, director of the Polaroid 20 x 24 Studio in New York,
without whose help these images could not have been brought to life, and Stacy Fischer,
manager of the studio.

Many of these photographs were originally exhibited at the Laurence Miller Gallery in New York City.

What's your background in photography?

I fell into it by chance. I went to college in 1966, thinking I was going to be a constitutional lawyer. (Obviously that didn't work out.) In my freshman year I took a noncredit class on photography given by some hippies at what was called the "Free University" at Stanford. Before starting the course, I went out one morning at 4 A.M. to Pescadero Beach and photographed with my father's Nikon. I had one of those epiphanies that this was what I wanted to do. I was an Edward Weston–Ansel Adams kind of photographer, although I didn't really know who they were. I was making these very sensual images of rocks and sand, and about a year later I was in a show and I sold one of those photographs. I was hooked.

You've said that you became interested in urban subjects, changing your flag from Weston to Atget, during the summer you came East and attended the Rochester Institute of Technology's intensive program in photography. Did Atget's storefront dummies influence your interest in toy figures?

I think so. My memory is vague but I must have been looking at his work. One of my favorite photographs from that summer is a shopwindow full of hats on Styrofoam heads. There's a definite connection.

You're part of a generation of photographers who are not so much engaged by reality. Why do you think you have taken your cues from film, painting, even other photographs, rather than from the world around us?

Partly because that is the world around us, and partly because when I was in art school at Yale in the early '70s I think a lot of us realized that going out into the street and documenting it with a camera had already been done. My first year at Yale I went around shooting out of my car. That was a very Lee Friedlander–Danny Lyon way of working: using the window as a frame. When I began to photograph toy soldiers in 1972, my teachers didn't understand the work at all. Linda Connor, who was the visiting artist that semester, was the only one who shared my enthusiasm. But when you're young, that's all you need. Photography in museums was basically the world according to John

5

Szarkowski. I think my way of working was more popular than I realized at the time, but there wasn't this communication network of art magazines and galleries that exists now. I think people are always looking for other ways of doing things. Once there was encouragement for that kind of work, more and more people began to photograph in that style.

How did you hit upon the idea of photographing toy soldiers for your first book, *Hitler Moves East*?

For my thesis project at Yale, being the guilt-ridden child that I am, I thought I really should learn something instead of just doing what I wanted. I hated working in the studio, so I decided I should teach myself that skill. My first plan was to photograph a doll house. I went to the store, bought a Marx doll house, set it up, and quickly discovered it was much more complicated than I had thought. Not so much the lighting, but all the interior spaces. So I went back and bought some toy soldiers. They happened to be German infantry-men. For some reason, this struck a very responsive chord. I photographed the wrapped box, then the box being torn open, then the soldiers standing there on white paper. It was a kind of Dada exercise: I knocked one over to pretend that he was dead. Then while our family was skiing in Colorado over Christmas, my youngest brother, Dan, found some soldiers with these beauti-ful dioramas. I bought them and photographed them on the floor of my childhood bedroom in California, using these Kinder City blocks. I ended up making several hundred prints during that vacation.

How did you and your collaborator, Garry Trudeau, arrive at the idea of the project?

I was up in Cambridge when I happened upon this book, translated from the German, called *Hitler Moves East*. It was this wonderful historical narrative that read like fiction. I showed it to Garry, who really liked it. It was the pub-lisher of his cartoons, Jim Andrews, who suggested we work together on a book. We started it at the end of '73 and it came out in '77. My work under-went enormous changes during that period. I used documentary photographs as the basis for my imagery. I was looking at literally thousands of them in history books. There were so many photographs of the Eastern Front, and after a while you would begin to see similar kinds of images. The German soldier, crouched, and running up the street with a machine gun; or the soldier running

between two train cars. What I tried to do was assimilate those images and make something that would capture that feeling. At the time I was simply looking for ideas and trying to make it look real. As time wore on, I started to make the images more credible.

Why did you choose to portray German soldiers rather than, say, American?

Garry and I decided to use the Eastern Front because unlike, say, D-Day, people didn't have clear ideas about it. They didn't realize that's where World War II in Europe was won or, put another way, where Germany lost the war. There was complete visual freedom. I probably did three generations of imagery. The first was cleaned-up graduate school material; then I found some painted HO scale figures from Spain. Garry then suggested that I paint all my other figures, which I did—some in four-color camouflage uniforms—which is probably why I need bifocals today. Fortunately, I found larger figures that you built. Those were primarily the ones that I used. Working with a collaborator was very important. Artists tend to be conservative by nature; if something works, you keep doing it. Garry pushed me to try new things.

The book has acquired cult status. Didn't Cindy Sherman tell you that she had looked at it when she was in art school at HALLWALLS in Buffalo?

She said that she and her friends had seen it. Certain people knew and liked the book, which is gratifying because at the time I felt that I was working in something of a void.

Have you changed your way of working over the years?

Once I get the idea going it becomes a question of problem solving; now I think I'm more reactive. With *Hitler Moves East,* it was: How do I make snow or a wheat field? With the cowboy series, it was less regimented. I discovered effects as I went along. I work in a narrative style. I used to tell people that all my work was intentionally ambiguous to draw the viewer in so that you make your own story.

What are the origins of the cowboy pictures?

I think the Western work was heavily influenced by my age, because I grew up in the '50s. I loved cowboys as a young child. My mother has told me that I had a favorite cowboy shirt and she would stay up late and wash it so that I could wear it the next day. And I wouldn't go out without my Red Ryder gloves. I remember going to the movies with my father on Saturday and seeing bad Westerns. (*I* knew they were bad; they must have been God-awful to *him*.) I remember being very jealous of a friend who had the whole toy-gun set—the bandolier and the Winchester rifle that fired plastic shells. He was the envy of everyone on our hill. I watched innumerable Westerns on television. One network in those days had a rotation of cowboy programs. They were as plentiful as sitcoms are today. And I remember listening to *Gunsmoke* on the radio during car trips. All those had a great influence. You absorb everything in your life. If you're an artist, part of your life is synthesizing these elements. But you don't want to know too much about your own past. Subconsciously it's stronger; if you're consciously trying to relive your life, it looks too programmed.

Was there a more immediate stimulus?

I remember looking at Jim Casebere's Western work, particularly his piece of a covered wagon shot through with a bunch of arrows. That kind of triggered me—or maybe I should say retriggered me. I recently discovered a small group of cowboy figures that I shot in 1972 and completely forgot about. It was a stage when I wasn't trying to hide anything, although I blurred the focus and moved the camera to make them less obviously toylike, techniques that I later used for *Hitler Moves East*. I was mimicking childlike scenarios. Then, shortly after I moved to New York in 1983, I remember going to the old Film Forum and seeing John Ford's *The Searchers*. I was just overwhelmed by it. In about 1985, while I was working on the Modern Romance series, which were these tiny people, HO scale, based on ideas from Edward Hopper and *film noir,* I went out and bought a new set of Britains cowboy figures, which were plasticky but quite beautiful. I set them up and shot them with my 4x5 camera, which I probably hadn't used in about eight years. One photograph I took had these wonderful red-orange hues, probably because of the light I was shooting in. I saved one of the cowboy pictures. I began shooting them with Polaroid SX-70s, mainly for practical reasons. I didn't have a darkroom and I liked working with color.

What's the attraction of the Polaroid process?

The immediate interaction. You can see what you're doing and make changes in real time. The size and the richness of the color on the Polaroid 20x24 camera is also very seductive.

How much time do you spend planning and shooting a series?

In the course of a day I can do between seventy and ninety exposures on the Polaroid camera. At one time I held the record, which I think was broken by Bill Wegman. I might do twelve to fifteen scenes. I can change sets very rapidly. Our lighting was incredibly simple for the cowboy series, often only one light with maybe a fill on the side. When I was building my own sets, I would allow at least a day for that.

How many scenes are set up here in your loft and how many are set up at the shoot?

I used to go in with SX-70s or crude sketches; I do that less and less. Now I tend simply to write down a phrase that links a figure with a setting or feeling.

Once you had a day scheduled in the Polaroid studio, how did you prepare for the shoot?

Frankly, my original idea was just to translate my SX-70 ideas to 20x24s. I had shown them along with some of the figures to John Reuter, who runs the Polaroid studio. I had about a half-day on the camera, we shot about eight exposures, and they were terrible. The figures looked awkward or just stupid. It wasn't whatever it was I thought it was supposed to be. The next time I had a day on the camera we set up a couple of things. John worked on the filtration for this reddish light that I wanted. And after a few shots, it looked perfect. I don't think we changed the filter pack after that. I realized that I couldn't mimic the SX-70s, that it was a different way of looking at things. What I discovered over time is that the scenes with fewer figures—two gunfighters—were much more interesting. The first really successful piece was the cowboy with a lasso on a white horse. I shot it and thought: This is exactly what I want to do. It captures my feelings about it. They're also more iconic.

Did you spend a lot of time in front of the television?

Far too much, I'm sure. But those were days when television wasn't twenty-four hours. It had a finite schedule. I once told my mother, "See, all those years in front of the TV weren't wasted."

I've often wondered if the scale of your figures—the tiny stature of toys—couldn't have been influenced by the reduced scale of figures on the television screen. An 8x10 photograph has about the same dimensions as an old black-and-white set.

I don't think so. If that was the case, it was subconscious. The toys were influenced by the fact that as a boy I had a large number of these Britains lead soldiers. I remember in high school I would set them on the floor and stage battles.

You were still playing with toy soldiers in high school?

I don't know that I was playing with them: I had them. I was thirteen when I was a freshman in high school. I remember drawing a floor plan of my room as though it were a geographic entity and having constituent groups who would fight, say, the Hundred Years War over this territory. Then I would have to redraw the map after each battle. Is this sufficiently embarrassing?

The hole isn't quite big enough, keep digging.

I would have a little battle. If you won, you earned more territory. But if your territory became too large, you became vulnerable and could be attacked by somebody else. And the course of the battles would depend on the shape of the figures. I remember that the Confederate lead soldiers had active poses. They obviously could be much more aggressive; the Black Watch soldiers were charging and could also be efficient. But the Coldstream Guards, who just walked, didn't fare so well.

10

How many soldiers did you have?

You didn't need that many. Only a few boxes. I had maybe ten boxes. I had two younger brothers and one of the reasons these beautiful lead soldiers are now destroyed is that they didn't survive being handed down.

Did you stop collecting and then pick it up again at Yale?

I wish I had continued to collect. When I was very young, my parents bought me this set of German-designed cowboy figures, beautifully painted, ceramic-like figures. I have this one figure of a cowboy and Indian wrestling with a knife that I managed to save and include in the cowboy series. My brothers conveniently only broke it at the waist and we were able to glue it back together. I would take birthday money and go down to this fancy toy store and buy a couple of figures. They were very "upscale" figures compared to, say, the Marx sets in which you could get a box of figures for the same amount of money. When I was in college—I wish I could remember why—I went back to the store and asked the owner where I could find these figures. He said they didn't make them anymore. That was my first entrée into the collecting world.

And that was motivated by loss—by the knowledge that these figures had been wiped out?

Maybe. I'm a very compulsive person. When I focus on something, I will spend an inordinate and inappropriate amount of time seeking it out. Sometimes I'll get an idea for a picture and I'll remember having seen an object somewhere years ago that I passed up. Now I want it. I'll take a long time to track it out, usually with some success. And sometimes the figure will work as an idea, and sometimes it won't. For my latest series, I've shot these Nibelungen figures with these severe, stylized sets that Fritz Lang used for his *Siegfried* and *Kriemhild's Revenge.* Conceptually I thought this was brilliant; it was a disaster. It was by chance that I tried these model railroad backgrounds with trees and waterfalls, and that worked beautifully.

You sometimes have a figure for years before you photograph it?

I'm object-driven in some ways. I'll collect a bunch of stuff and hope to find a use for it someday. For the American Beauties series, I found figures here and there at flea markets. But they just sat on my shelf for a couple of years until one day I brought them into the Polaroid studio just to see how they would look. I had been shooting cowboy stuff all day, so I just cleared the set. Fortuitously, all I had was sand. I stuck one of them in the sand, and I was stunned by how elegant it looked against the bare background. I knew I wanted to isolate them, to photograph them as sculpture. But they looked so good with the background fading to black, that's how I shot the whole series.

Does each set of characters require its own mise-en-scène?

Usually. A background that may work for one group of figures won't necessarily work for another. I have a set of Roman gladiators with lions—there may even be a few Christians thrown in—and I set them the way I did the cowboys. There was a little Colosseum. I shot a couple of 20x24s on the Polaroid camera, and for whatever reason they didn't work at all.

In photographing a toy figure, aren't you also sometimes translating into a picture from a toy figure that has evolved from a picture?

That's particularly true with the cowboy figures from Germany, which are actually called "Karl May" figures, after the German writer of Westerns. My suspicion is that they're based on paintings by Remington and Russell. It makes sense. If you were in Germany and someone said to a toy manufacturer, "Make me cowboy figures," where else would you turn? For that reason, the poses are more articulated and alive.

What is your toy budget, more than $50,000 a year?

I'm not sure I should say <laughing>. Some years more, some years less. But the toys I use, by and large, are not that expensive.

Is it the anonymity of the figures that allows the viewer to project a narrative onto them?

To some extent. For example, if you have a figure that shows John Wayne as Davy Crockett at the Alamo or Hugh O'Brian as Wyatt Earp—and there are such figures—then the picture becomes about them. I have a Batman play set. But you have such a strong sense of who these people are supposed to be and what's going on that you're limited. That's another reason I didn't title the work. Titles would either sound too hokey or too literal. With the Western figures, even if I wanted to mimic a scene in a John Ford film, I wasn't going to get so close that someone can draw the parallel. If you read *Hitler Moves East,* I think you come away with a strong antiwar statement. We weren't trying to make an antiwar statement, but we did the book during the Vietnam War, and that sense came through. I'm not sure if it would have come through if we had used figures who were based on Hollywood actors. We were able to make a very powerful document, totally fabricated. The idea was that certain images would look real; others would clearly be toys that would lead you back to examine the book and say, "They're all toys."

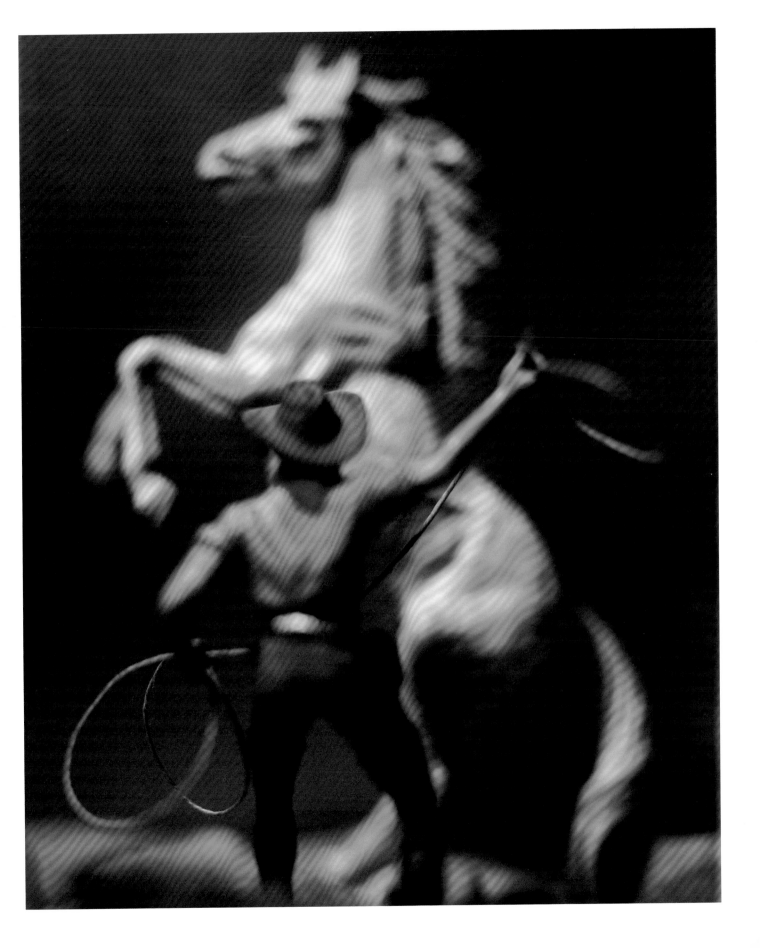

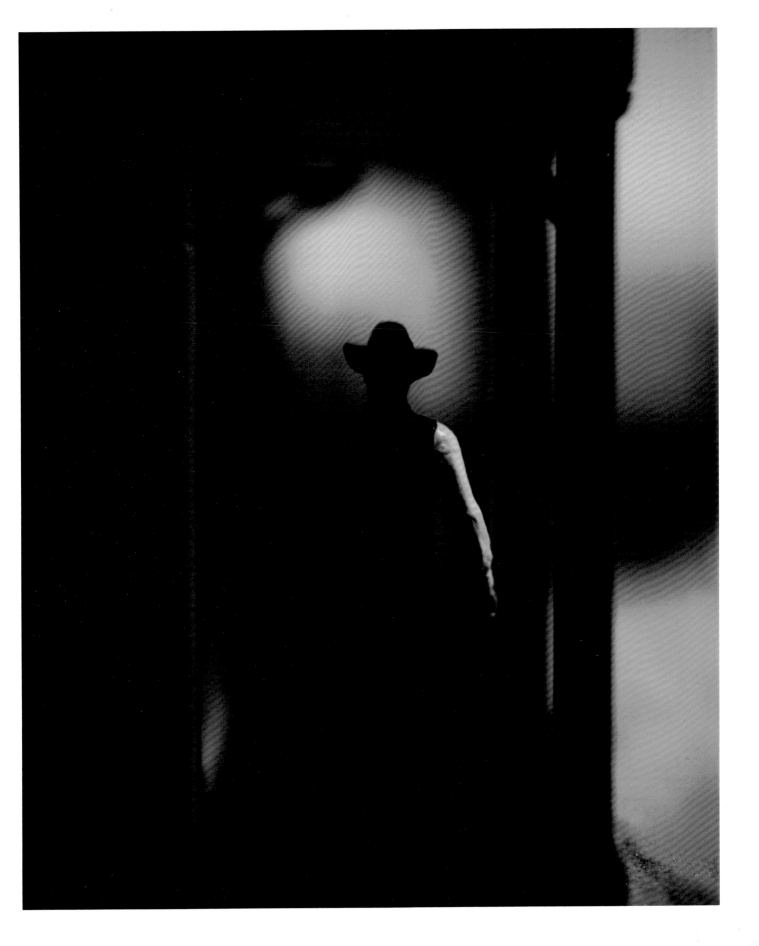

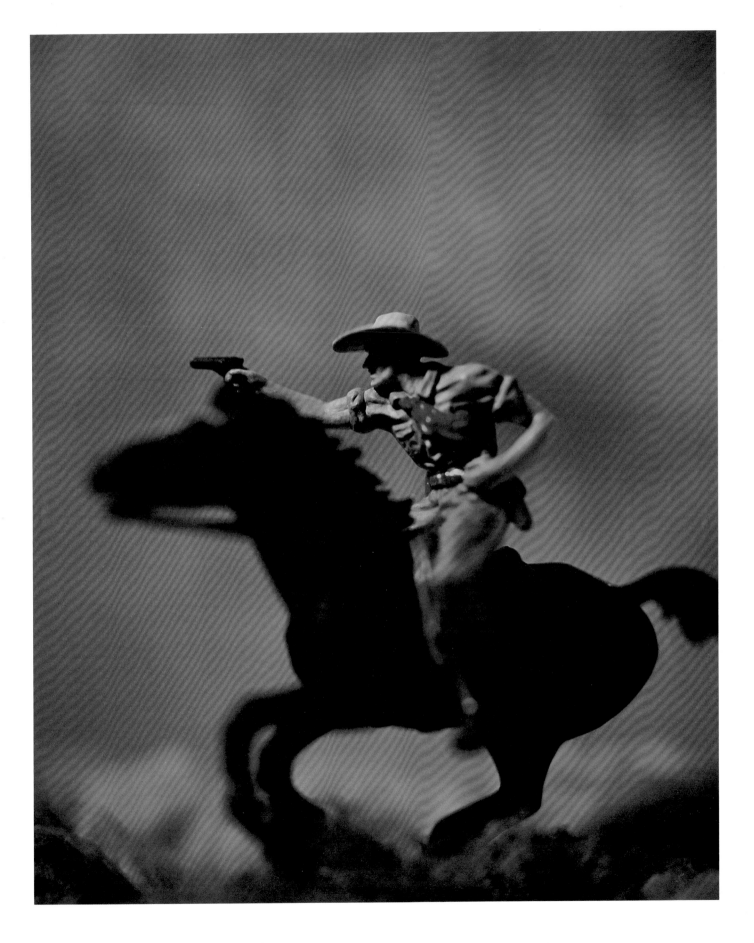

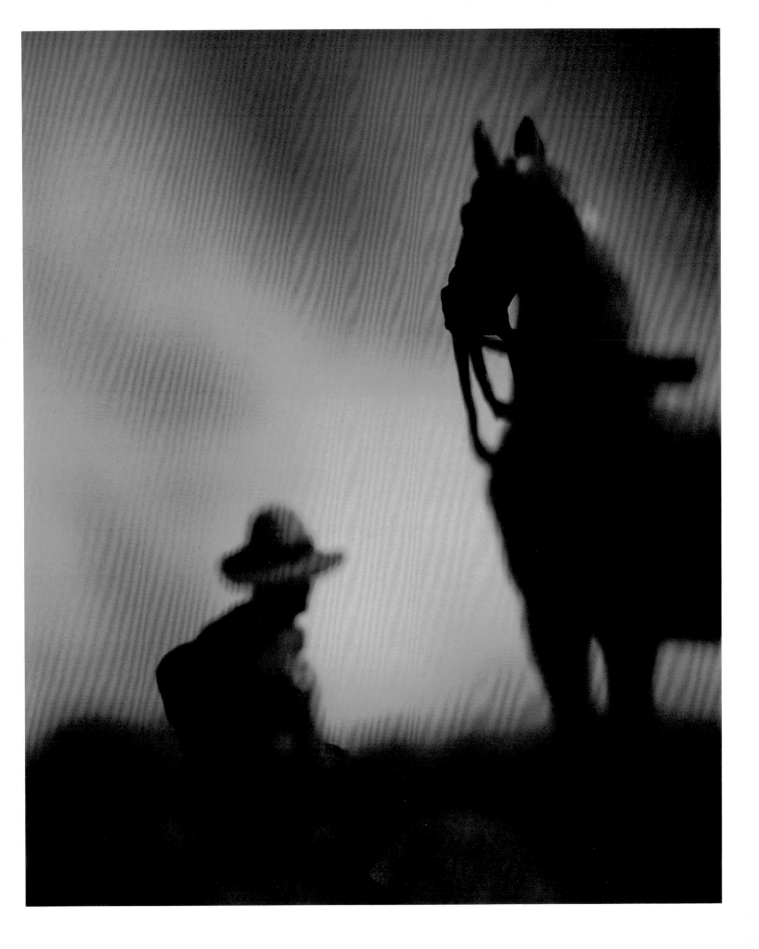

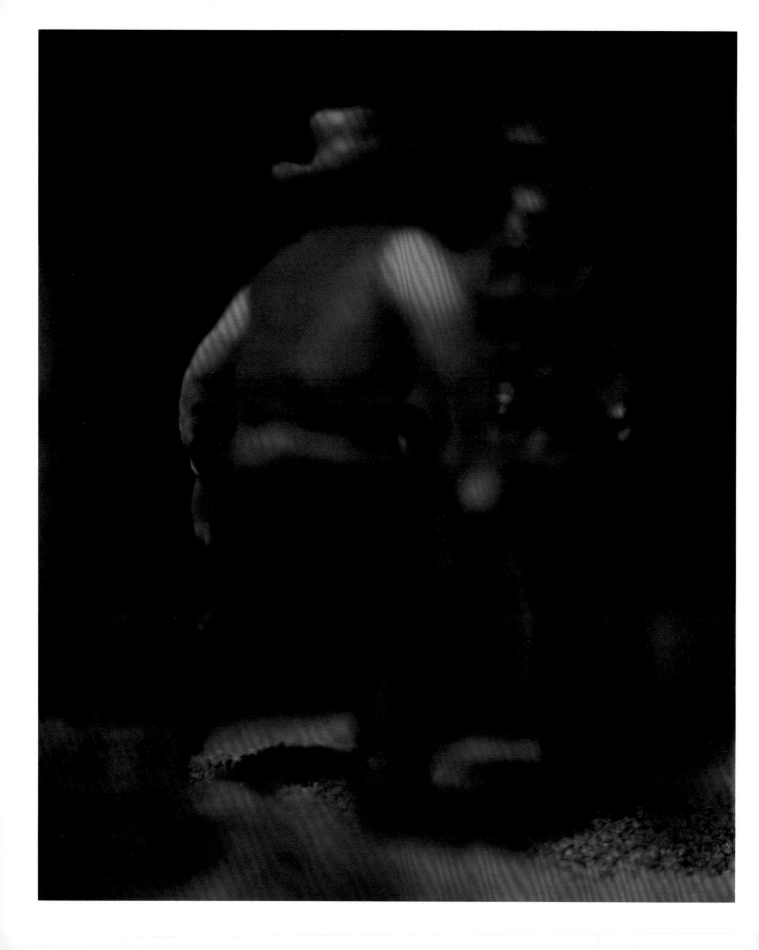

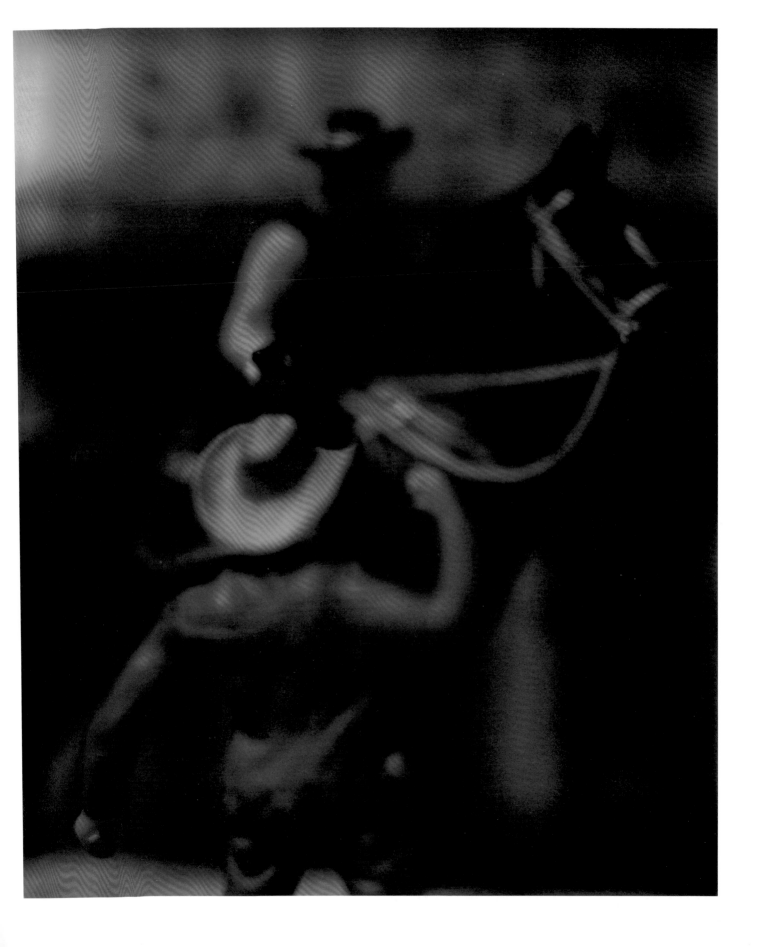

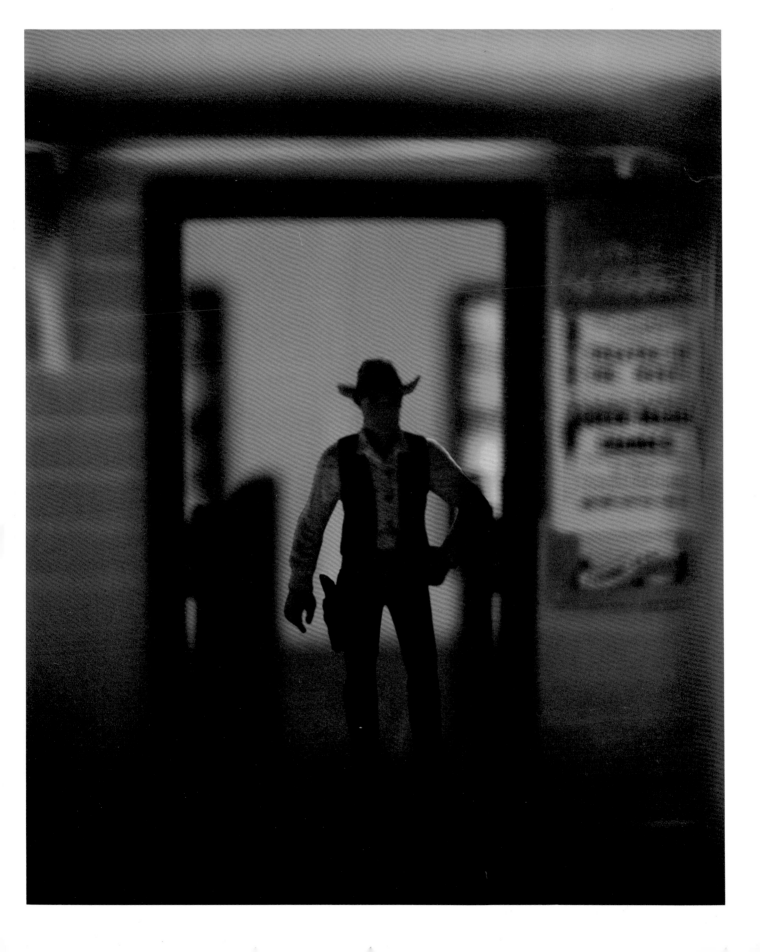

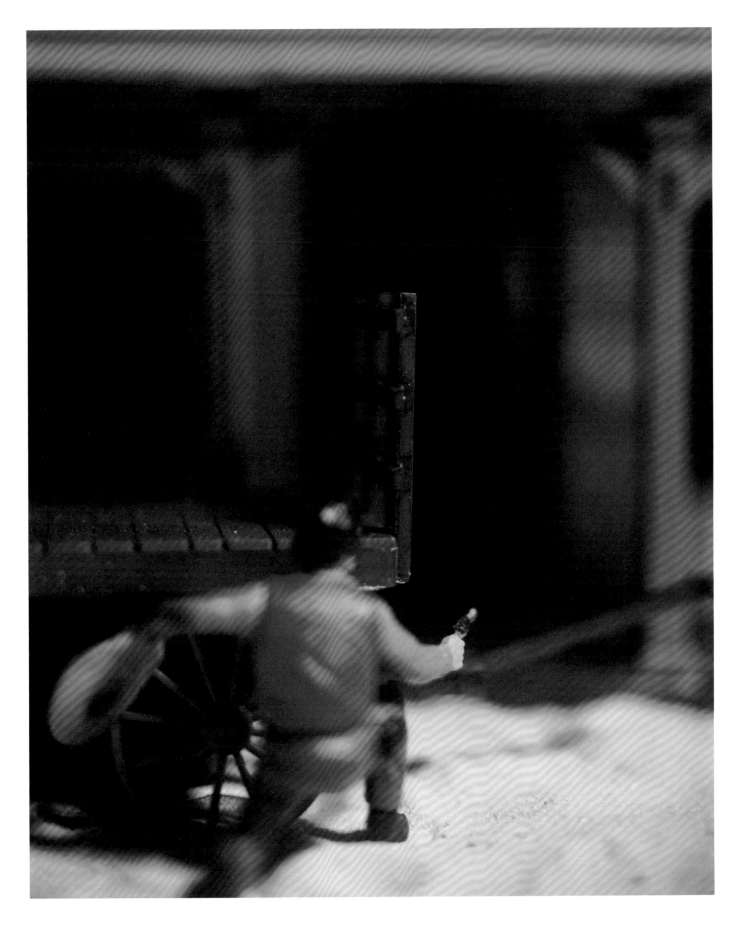

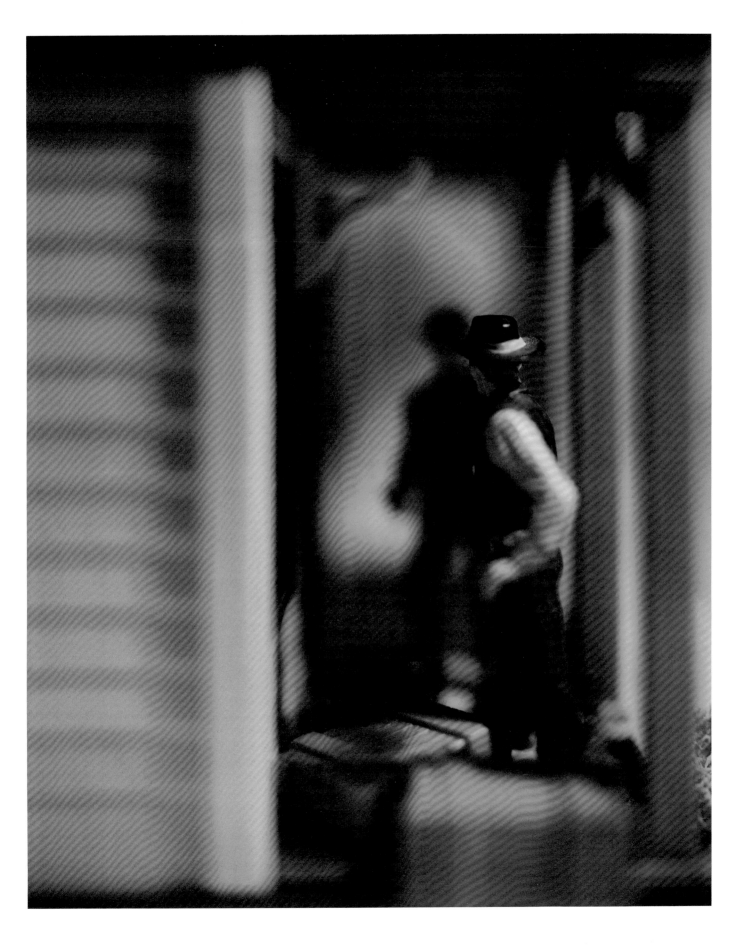

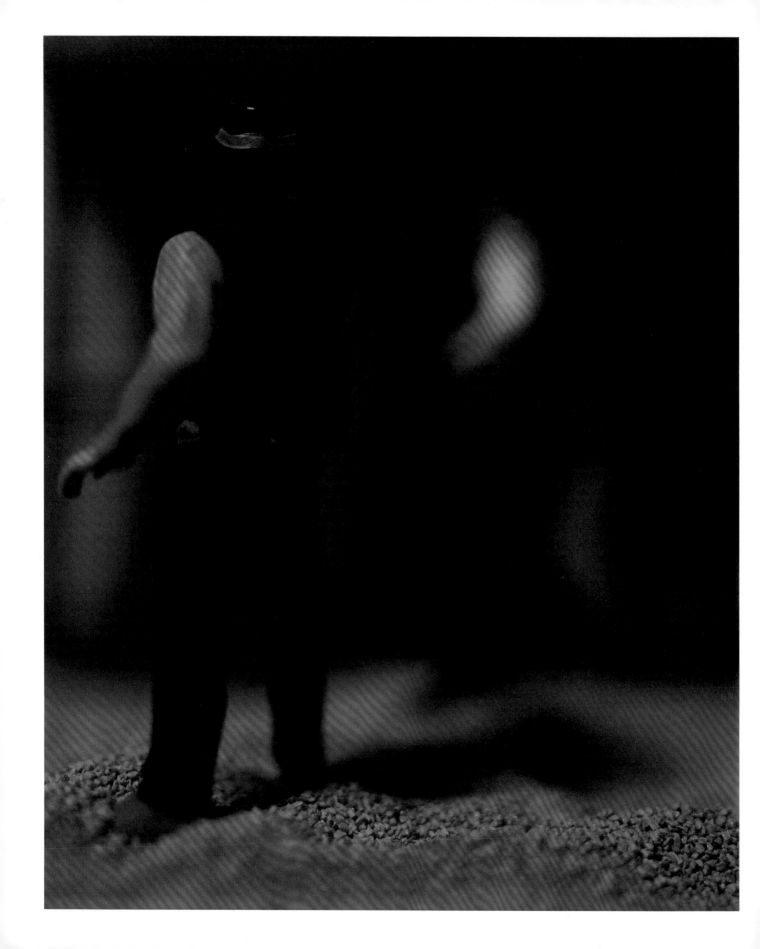

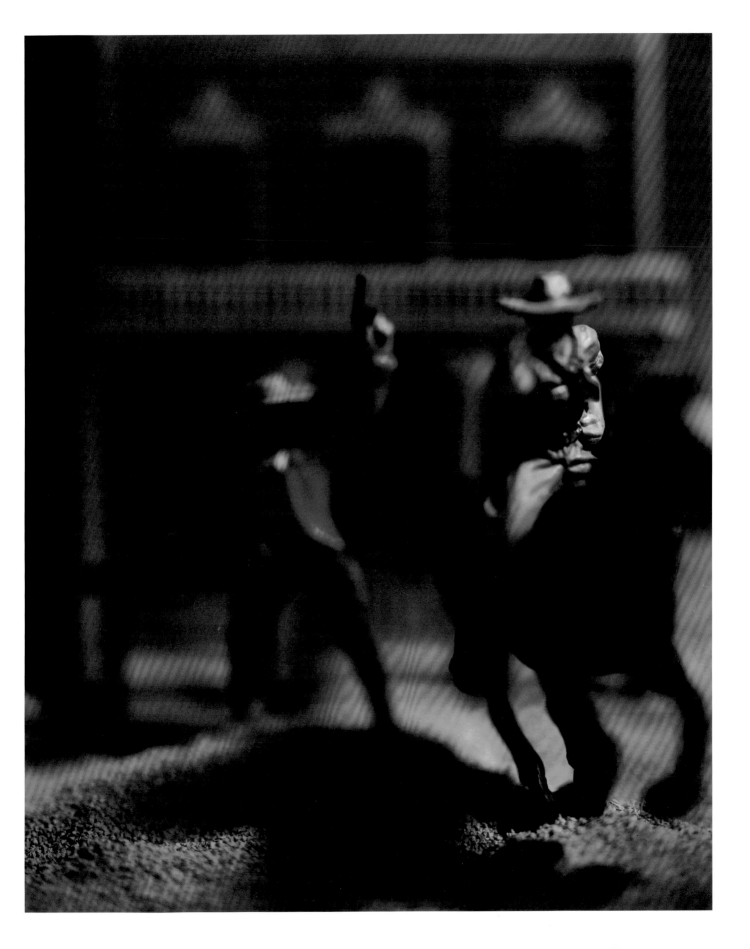

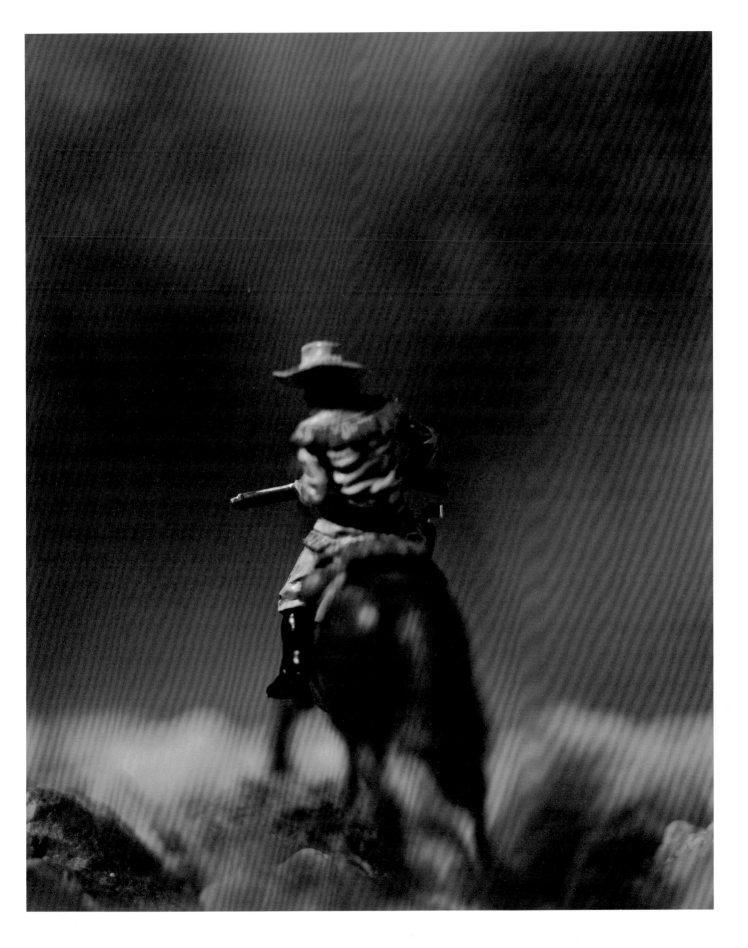

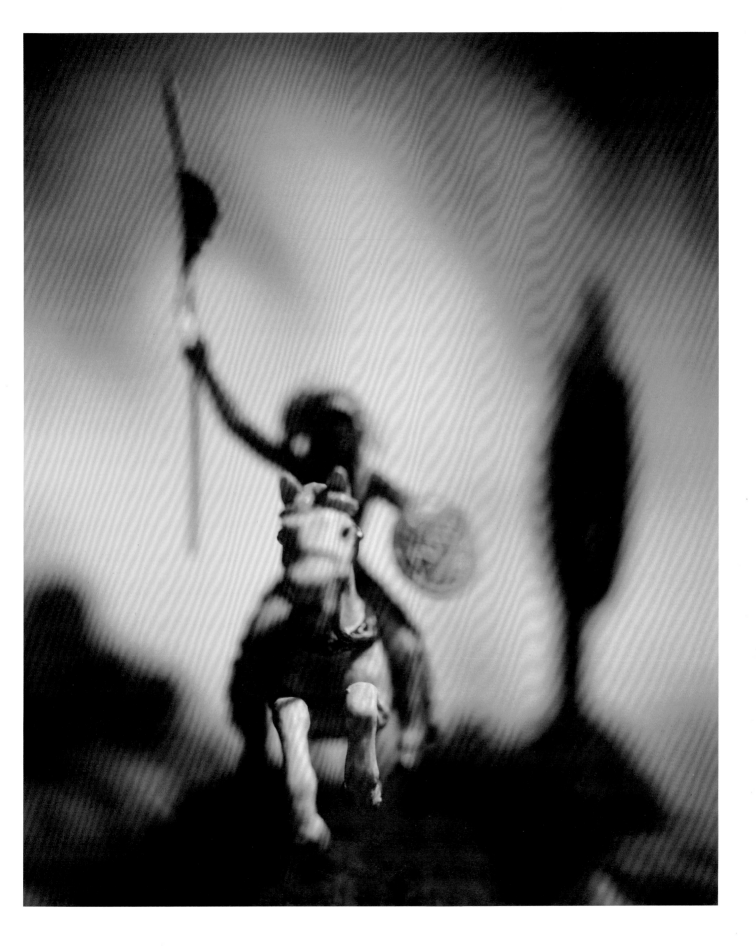

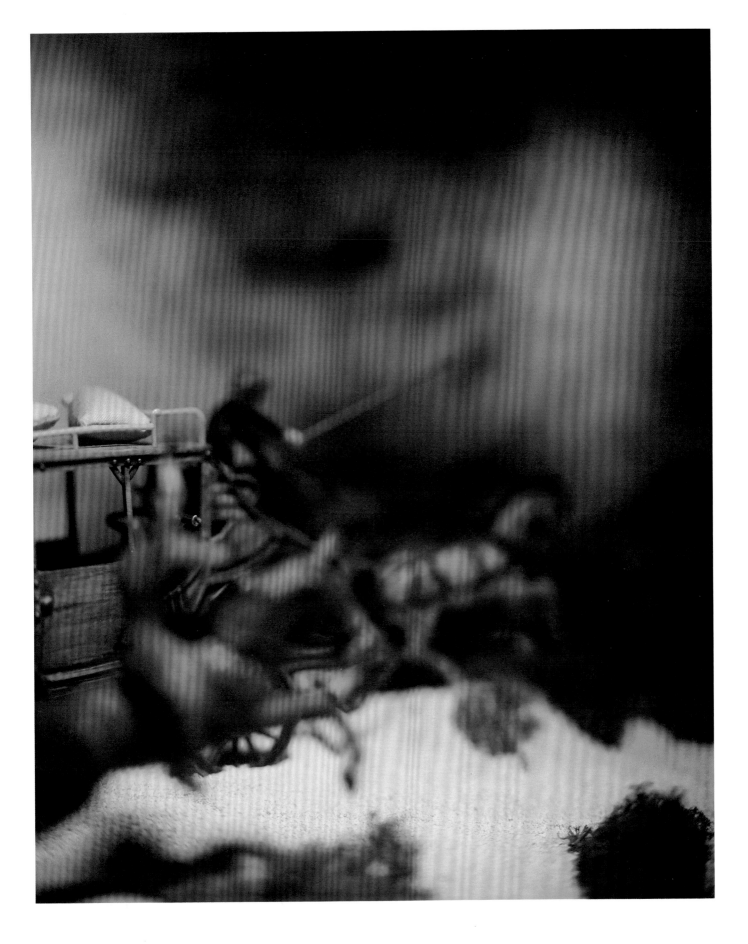

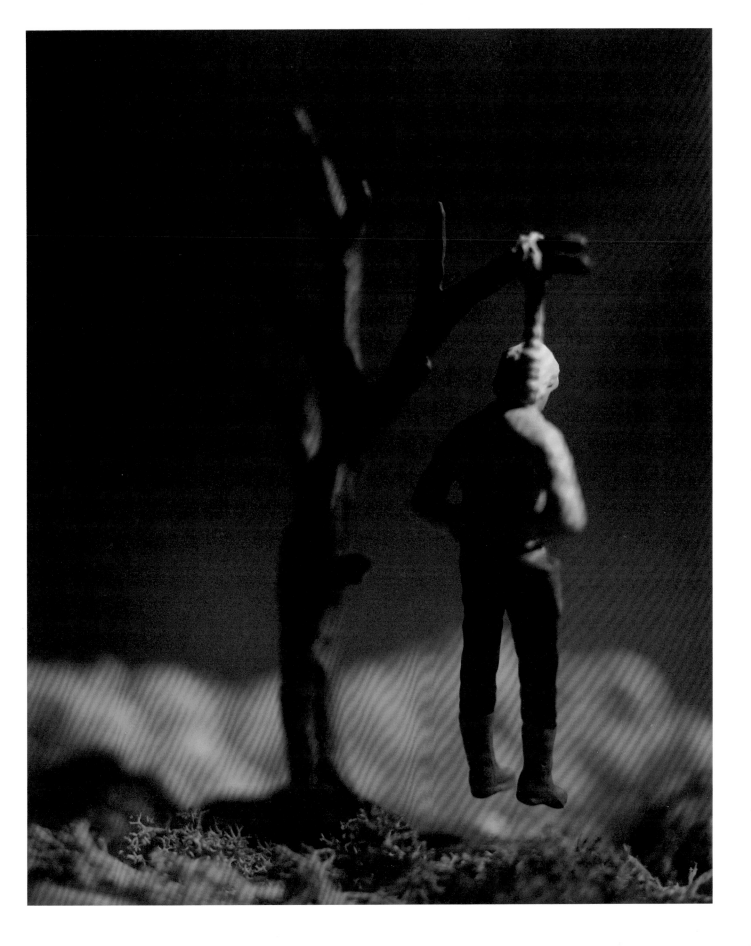

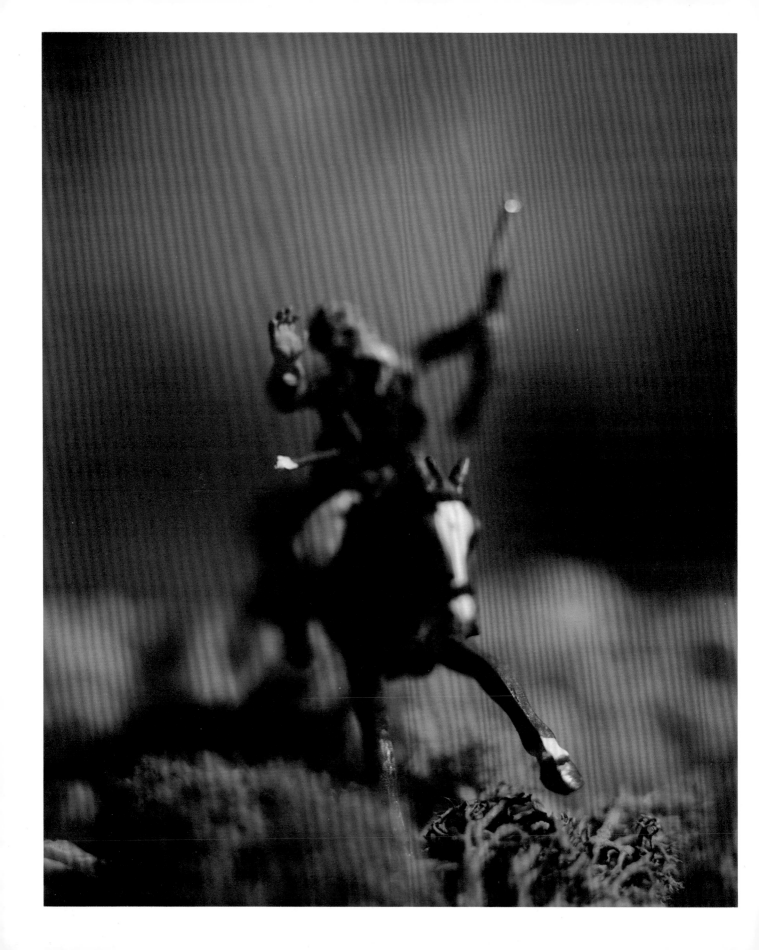

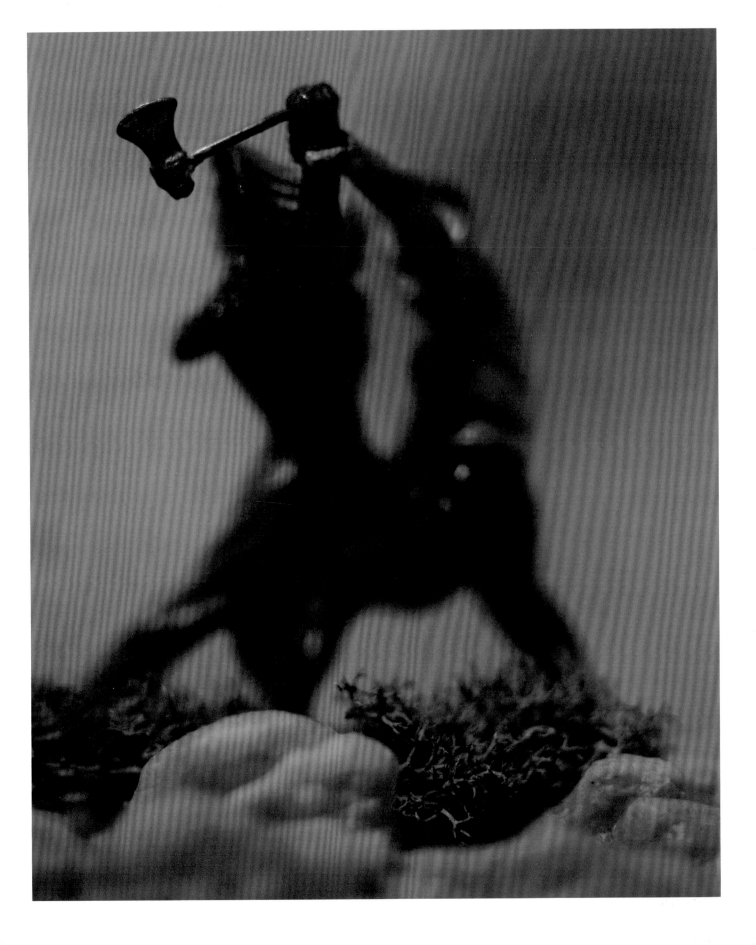

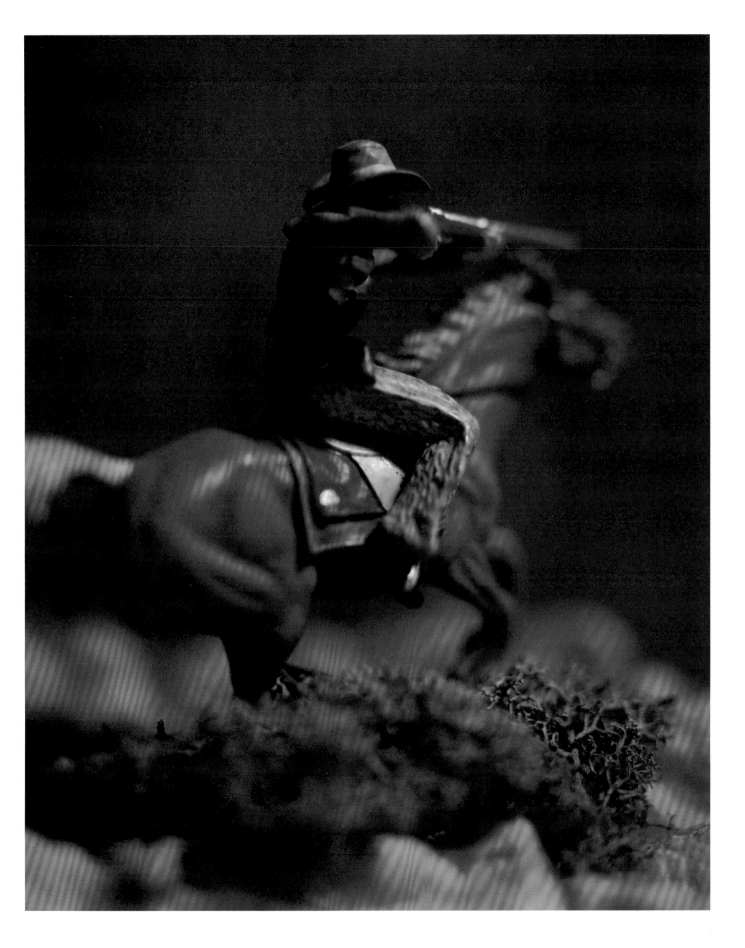

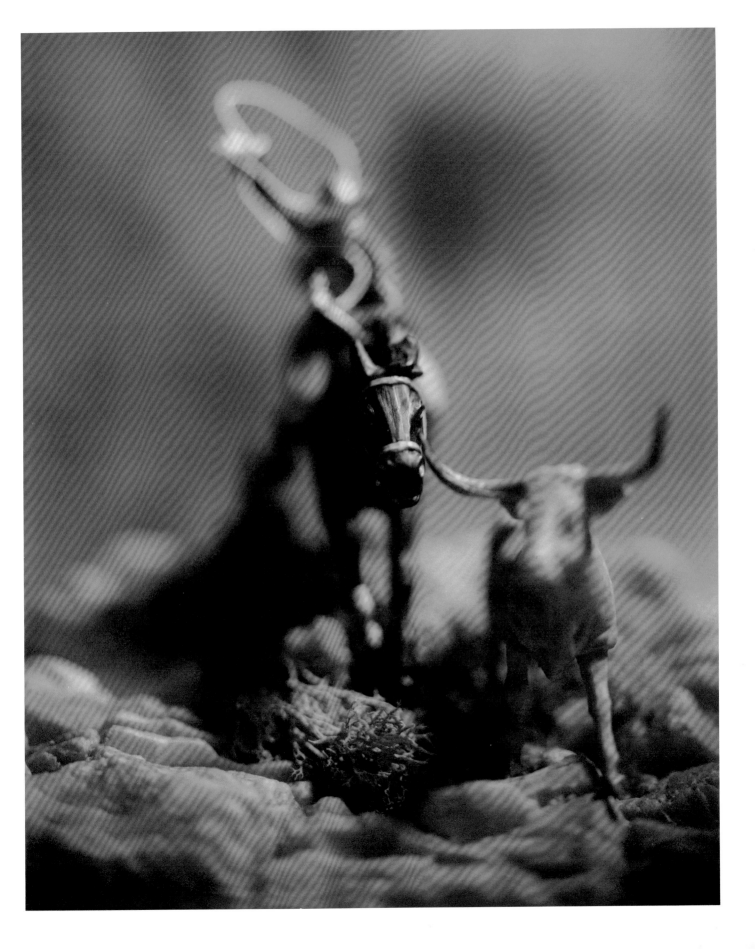

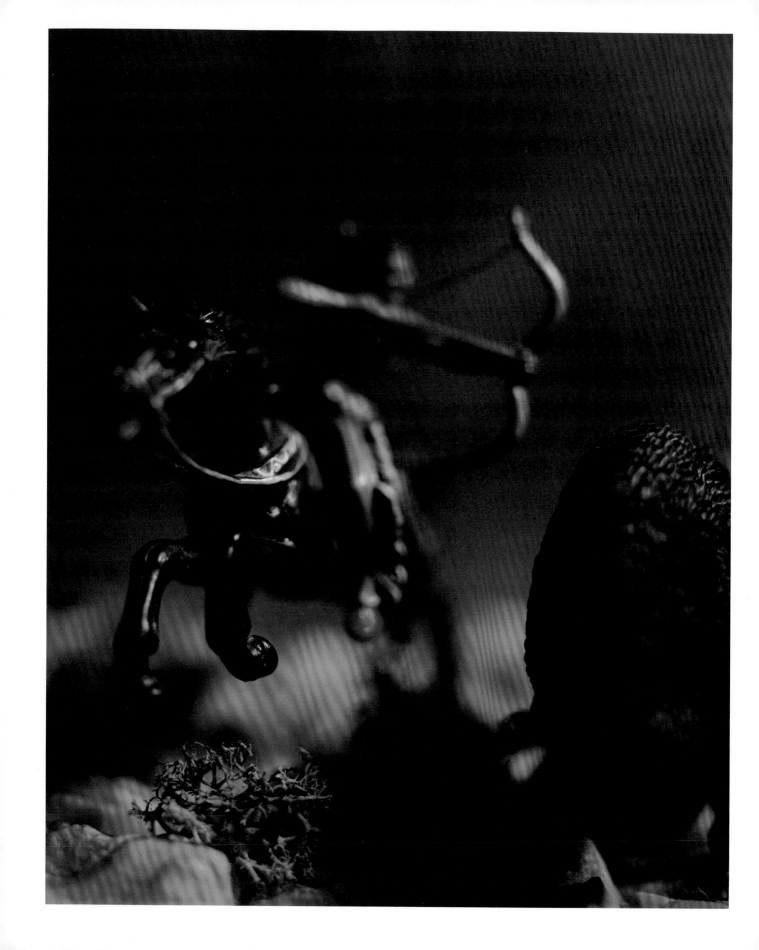

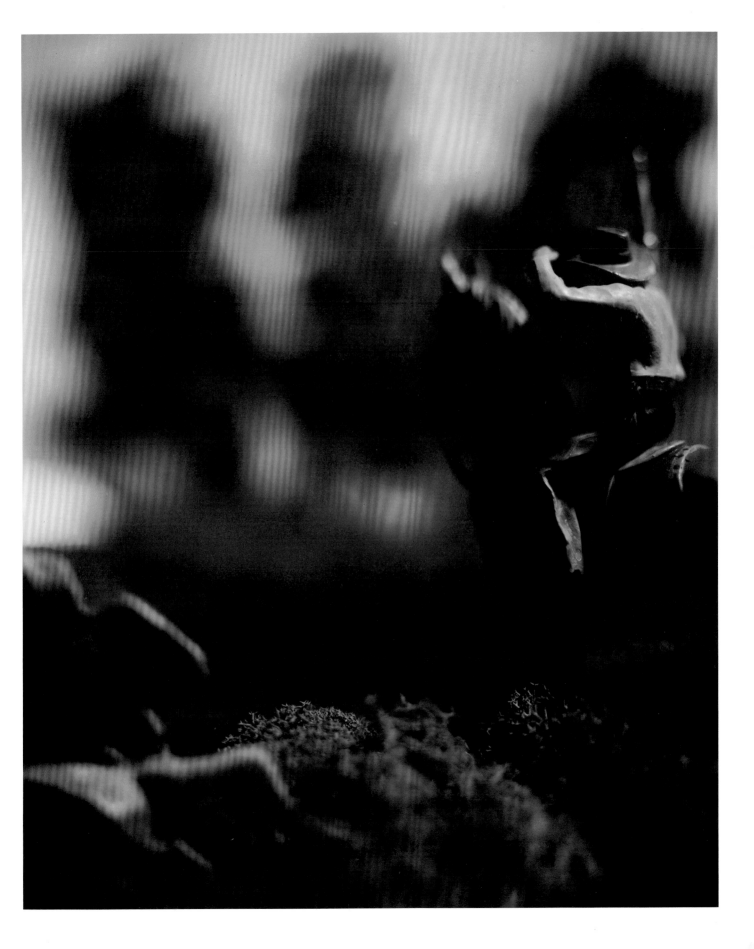

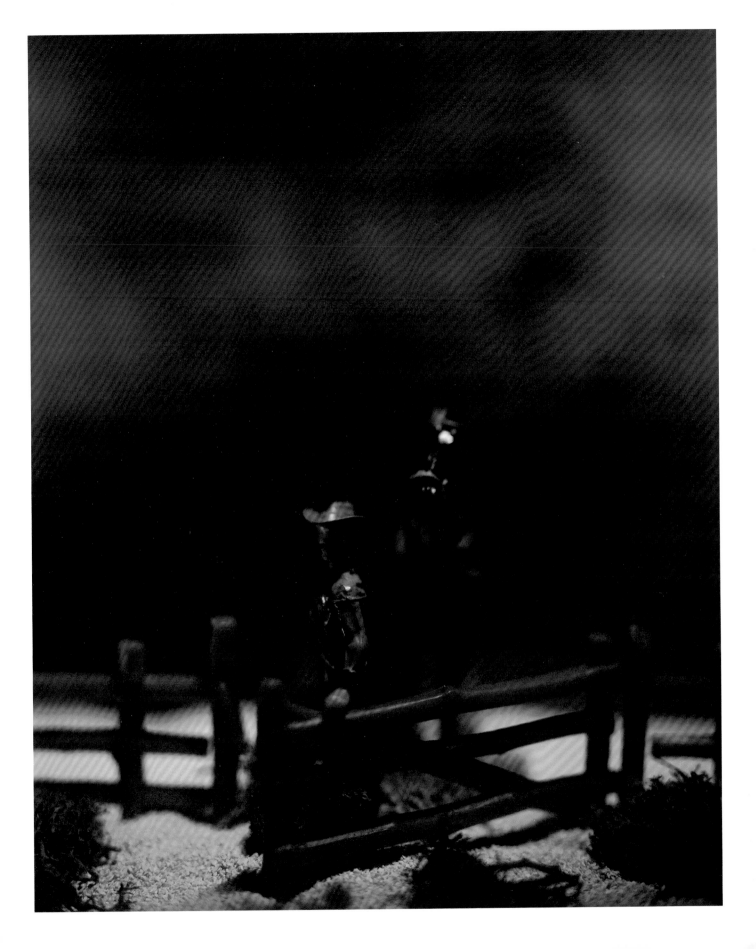

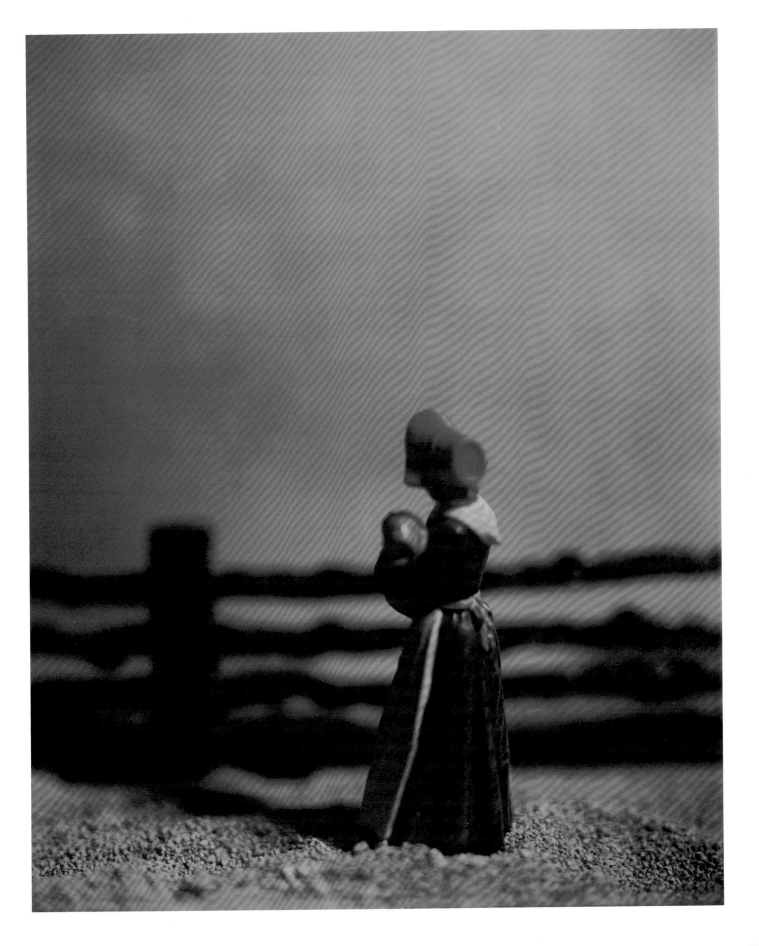

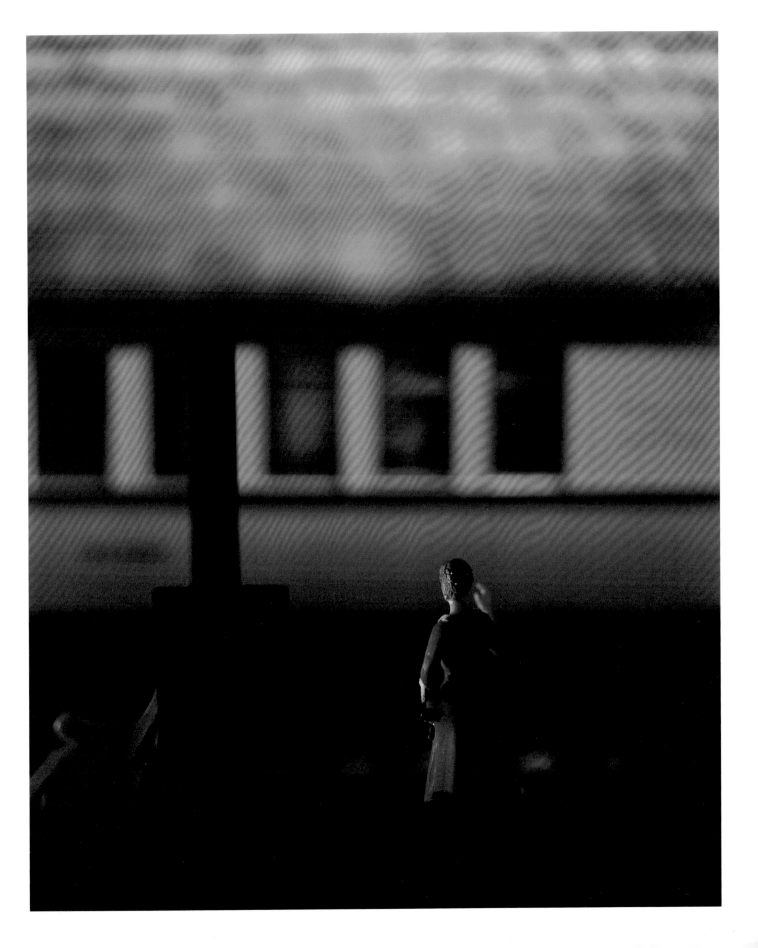

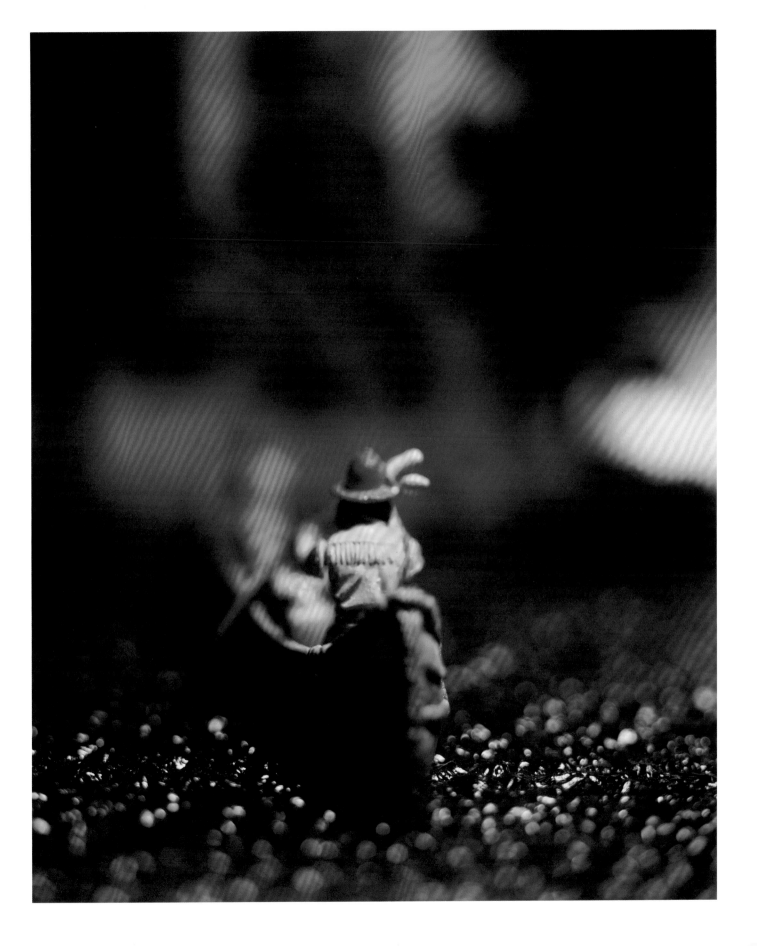

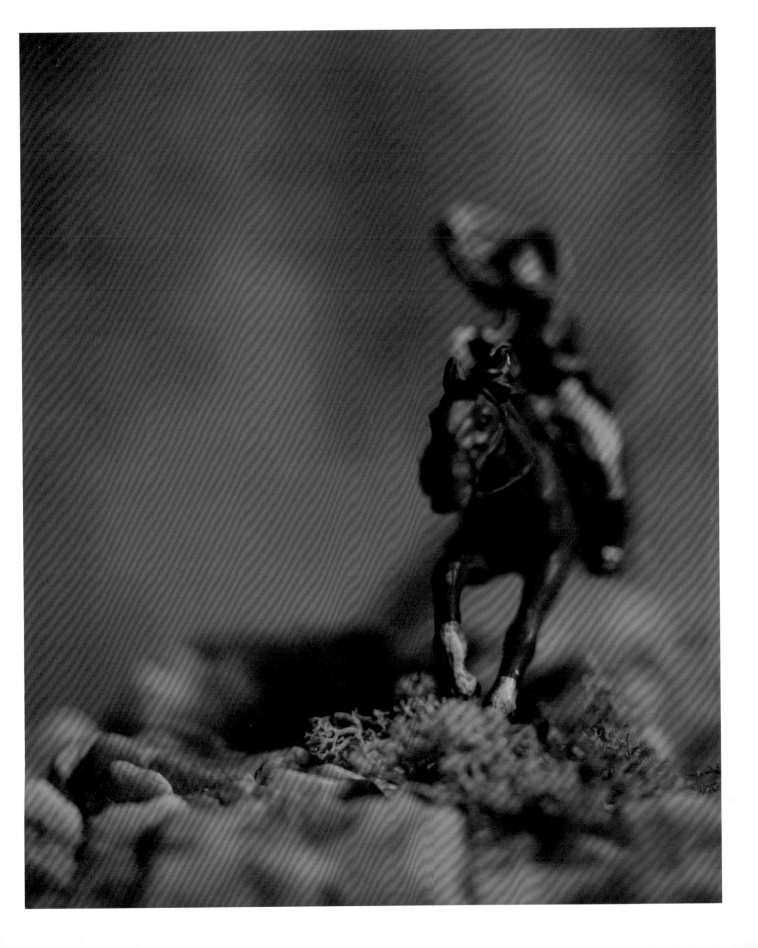

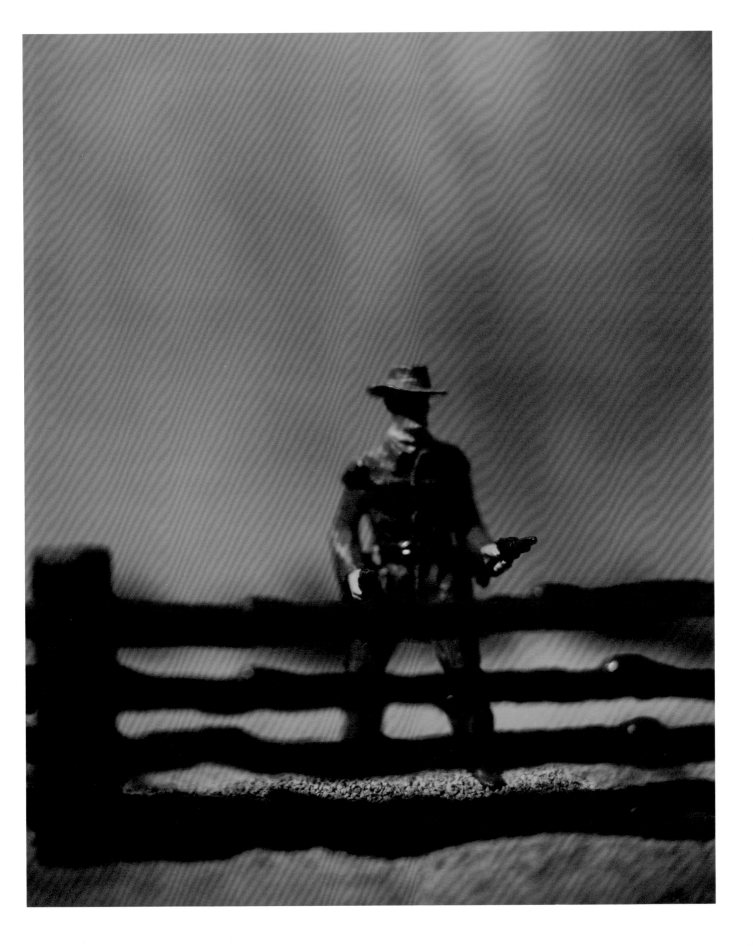

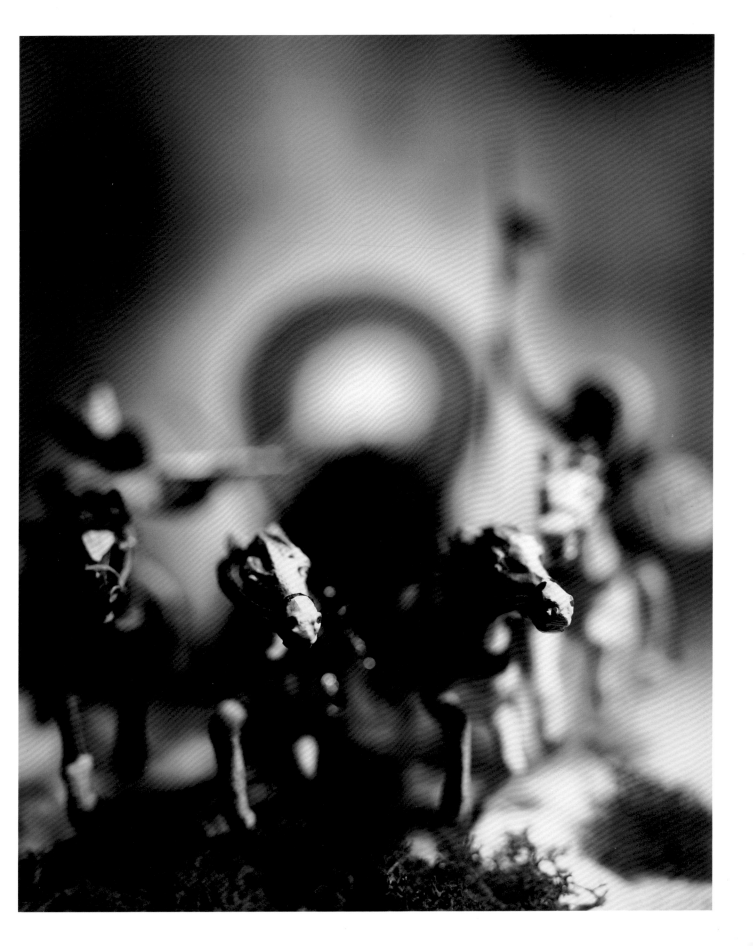

David Levinthal

David Levinthal was among the first photographers of his generation to elaborate an aesthetic of fabrication rather than of realism. For more than twenty years he has arranged toy figures in studio-constructed situations that mimic and cast doubt on representations of contemporary myths and American icons. The large-scale color photographs that he generates with the 20x24 Polaroid Land Camera give his effigies a seductive grandeur; at the same time, he is often careful to make visible the seams of simulation. Probing the nature of such pervasive imagery, as it has been transmitted, filtered, and blurred in films, television, books, and magazines, Levinthal nevertheless tries to evoke the genuine emotions that any of us can attach to an entirely artificial world.

Born in 1949 in San Francisco, he graduated from Stanford University in 1970 with a degree in studio art. After spending that summer in the intensive photography program at Rochester Institute of Technology, where he began to experiment with Kodalith materials, he entered the M.F.A. program at Yale University, earning his degree in 1973. In collaboration with the cartoonist Garry Trudeau, he produced the book *Hitler Moves East: A Graphic Chronicle, 1941–43,* using a range of soft-focus or out-of-focus techniques to bring the illusion of movement or depth to this pseudodocumentary of the German invasion of the Soviet Union during World War II. Its publication in 1977 can be seen in retrospect as a landmark of the movement that has come to be known as "postmodern photography." After earning a degree in Management Science at Massachusetts Institute of Technology in 198l, he co-founded a high-tech public relations firm in California. In 1983 he moved to New York, and has since devoted himself full-time to his art.

Each of the series of pictures that he has produced since the mid-'80s has a distinctive theme and palette. *Modern Romance,* published as a catalog in 1985, took as its inspiration the paintings of Edward Hopper and the shadowy, sex-saturated mise-en-scène of *film noir.* Posing toy men and women in front of a video camera, Levinthal photographed the images off a monitor; the grainy blue-green images of the lonesome figures—on street corners, in motel rooms and coffee shops, beside a swimming pool—are observed as though by a surveillance camera.

The Wild West pictures, begun in 1986 and based on the icons of the Hollywood epic—cowboys and Indians on horseback, pioneer women going about the business of hauling water and raising children—are photographed in the golden light of nostalgia. Described in soft focus to blur the distinction between still life and action shot, the characters reveal themselves only through movement, their hidden faces and clear, broad gestures reiterating the stoic philosophy of the Western.

An untitled series of outer space figures from 1988 explored the naïveté of imagined space travel—Levinthal at his most frankly cartoonish. *American Beauties*, completed 1989–90, is much more unsettling. Taking figures that date from the late '40s–early '50s, Levinthal has composed a dualistic universe for the single white female. These provocative and still-innocent toy fleshpots—nude, undressing, or clad in period swimsuits—cavort on a bright, clean strip of uninhabited beach against a black and somehow hopeless sky which seems to justify rather than mock their self-consuming pleasure-in-the-moment. *Desire,* a series from 1990–91, deals even more boldly with erotic material. The pose most often reproduced by the Japanese mail-order company which manufactured these pornographic figures shows a voluptuous nude woman in bondage to an unseen master. Levinthal asks the viewer to participate in the adult male sex fantasy, at the same time that his increased use of soft-focus delineates the action more than ever before as pure abstraction.

Levinthal's work has appeared in numerous one-man shows, notably at California Institute of the Arts, Valencia; George Eastman House, Rochester; Philadelphia College of Art; Museum für Gestaltung, Zurich; and Friends of Photography at the Ansel Adams Center, San Francisco. Recent work has been featured in group exhibitions at the Corcoran Gallery, Washington, D.C. (with Cindy Sherman and Laurie Simmons) and at the Museum Moderne Kunst, Vienna (with William Wegman and Eileen Cowen).

Some of the permanent collections that own examples of his photographs include the Museum of Modern Art, New York; the Museum of Fine Arts, Houston; the Hallmark Collection, Kansas City; the Amon Carter Museum, Fort Worth; National Museum of American Art, Smithsonian Institution; the Los Angeles County Museum of Art; and the High Museum, Atlanta. He is represented by the Laurence Miller Gallery, New York.

A traveling exhibition of the pictures in this book will open at the Gene Autry Western Heritage Museum, Los Angeles, in 1993.

— Richard L. Woodward

Technical Information

David Levinthal photographs primarily on the Polaroid 20x24 Land Camera, one of five constructed in 1977–78. All of the pictures in this book were made on an instrument in New York City with Polacolor ER 20x24 Land Film. Recently he has begun to photograph with a 4x5 Sinar on Polaroid 1000 color transparency film. Printing on Cibachrome paper is completed at Laumont Labs, New York City.